A BIG MISTAKE

For my mother and father, who always encouraged me. – L.R.

For a free color catalog describing Gareth Stevens' list of high-quality books, call 1-800-542-2595 (USA) or 1-800-461-9120 (Canada). Gareth Stevens' Fax: (414) 225-0377.

Library of Congress Cataloging-in-Publication Data

Rinder, Lenore.
 A big mistake / by Lenore Rinder : illustrated by Susan Horn.
 p. cm.
 Summary: A young artist turns a mistake into a beautiful painting.
 ISBN 0-8368-0674-3
 [1. Painting--Fiction. 2. Errors--Fiction. 3. Stories in rhyme.]
 I. Horn, Susan, ill. II. Title.
 PZ8.3.R472B1 1994
 [E]--dc20 94-7028

Edited, designed, and produced by
Gareth Stevens Publishing
1555 North RiverCenter Drive, Suite 201
Milwaukee, Wisconsin 53212, USA

Editors: Barbara J. Behm
 Patricia Lantier-Sampon
Designer: Kristi Ludwig

Printed in the United States of America

1 2 3 4 5 6 7 8 9 99 98 97 96 95 94

At this time, Gareth Stevens, Inc., does not use 100 percent recycled paper, although the paper used in our books does contain about 30 percent recycled fiber. This decision was made after a careful study of current recycling procedures revealed their dubious environmental benefits. We will continue to explore recycling options.

A BIG MISTAKE

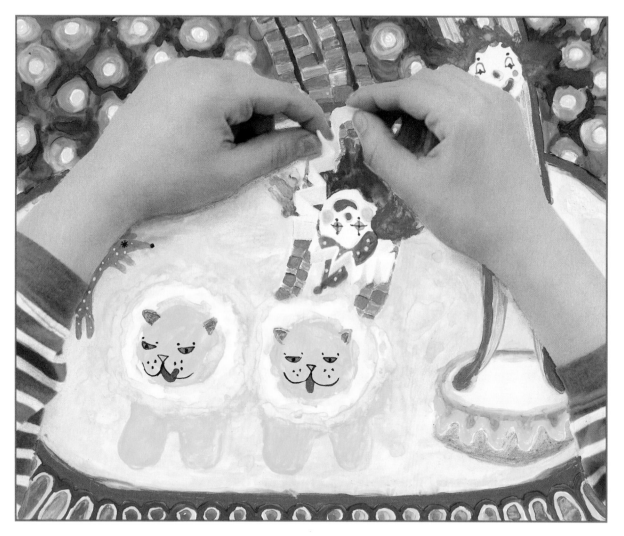

by Lenore Rinder • Illustrated by Susan Horn

Gareth Stevens Publishing

MILWAUKEE

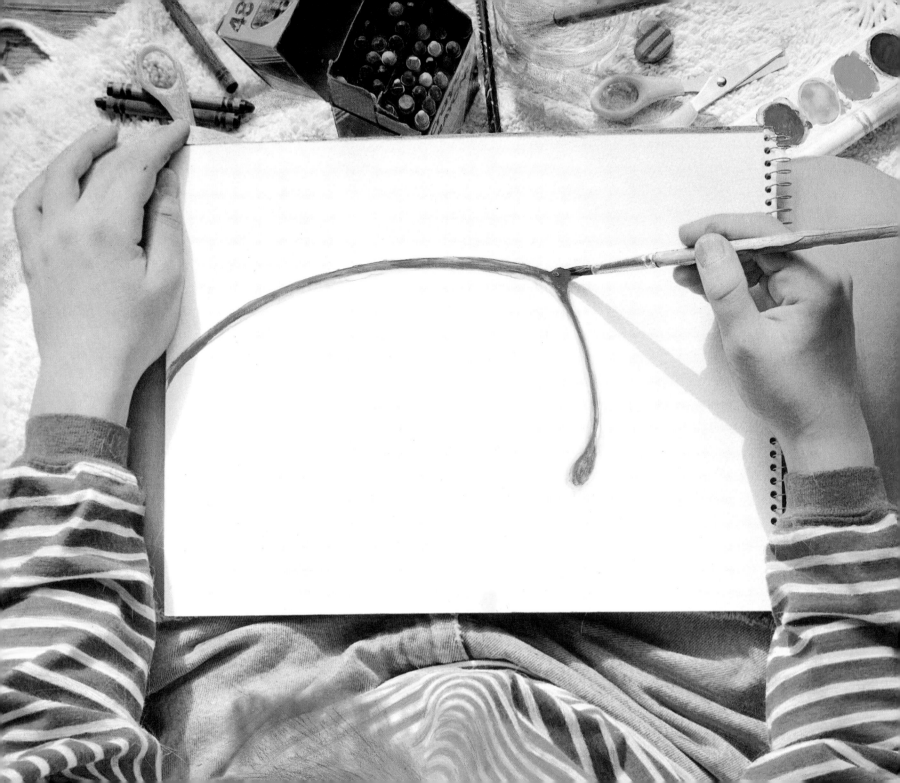

I was painting a line when my brush leaked a blob.

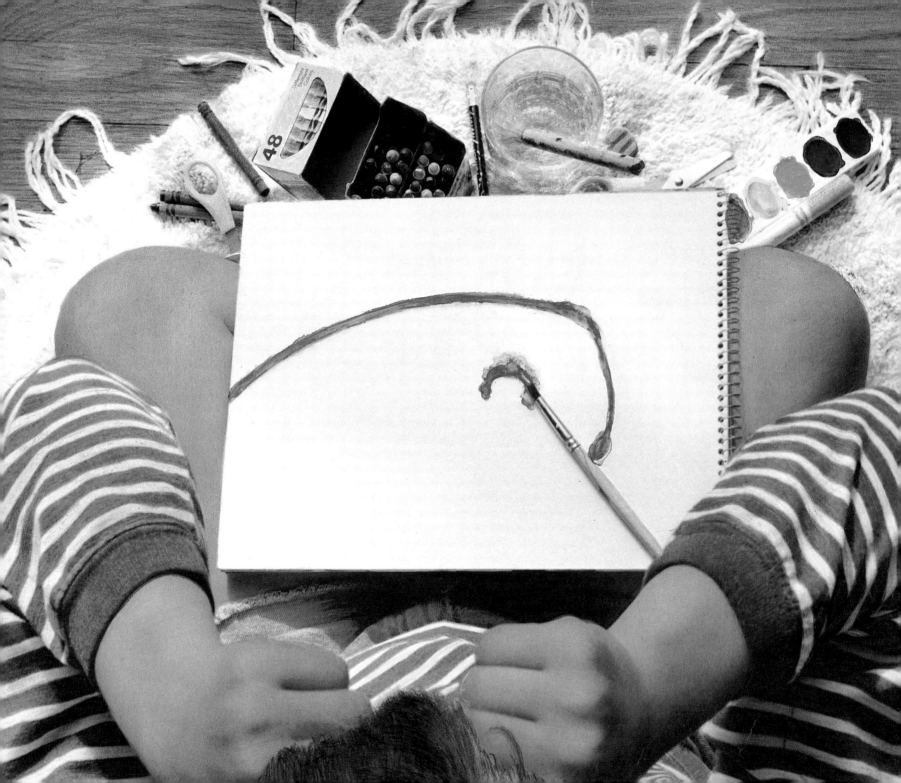

What a mistake! I started
to sob.

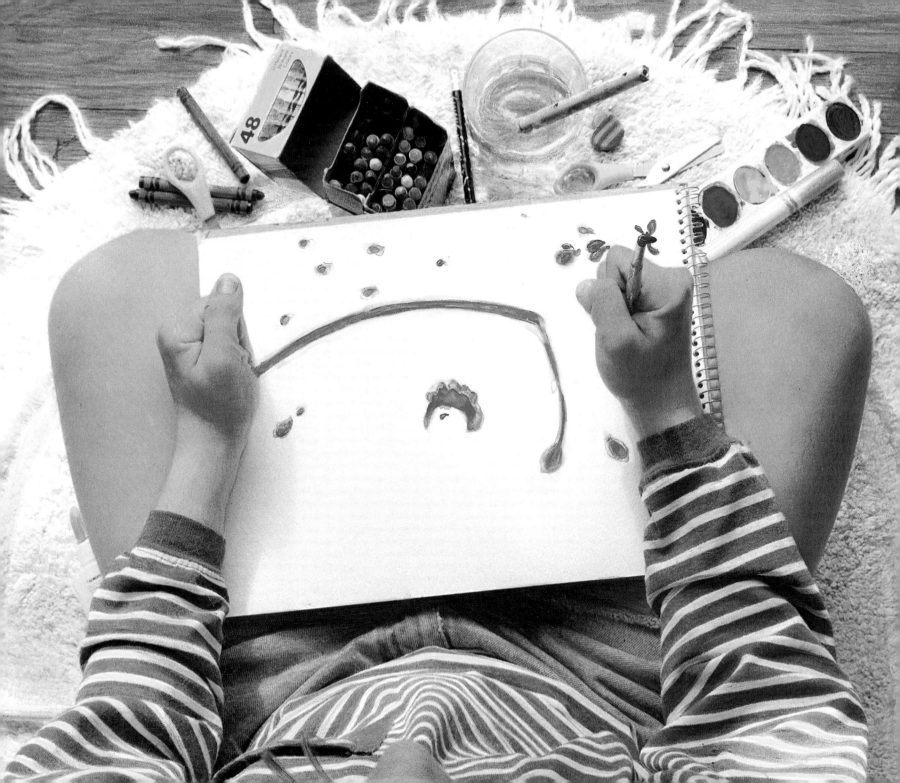

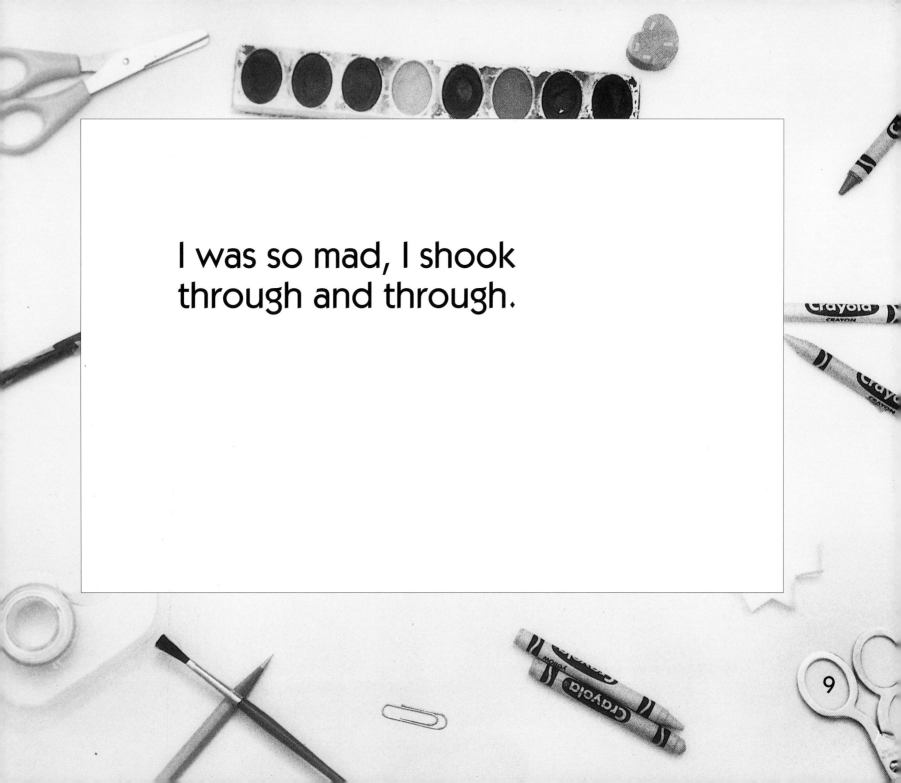

I was so mad, I shook
through and through.

9

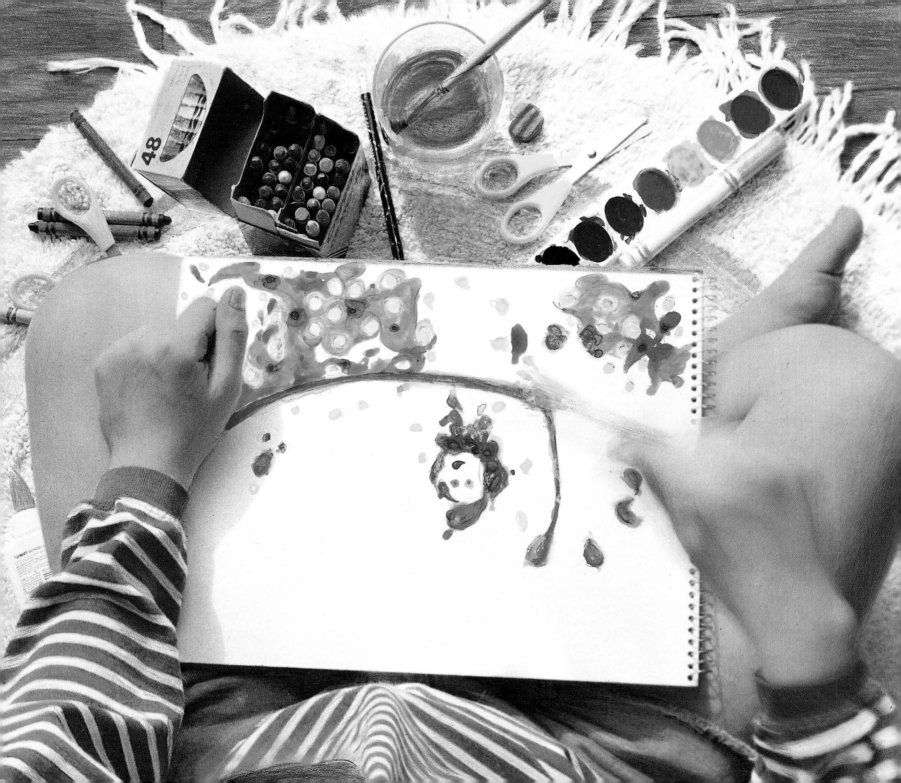

So I splashed on more
paint . . . some yellow,
some blue.

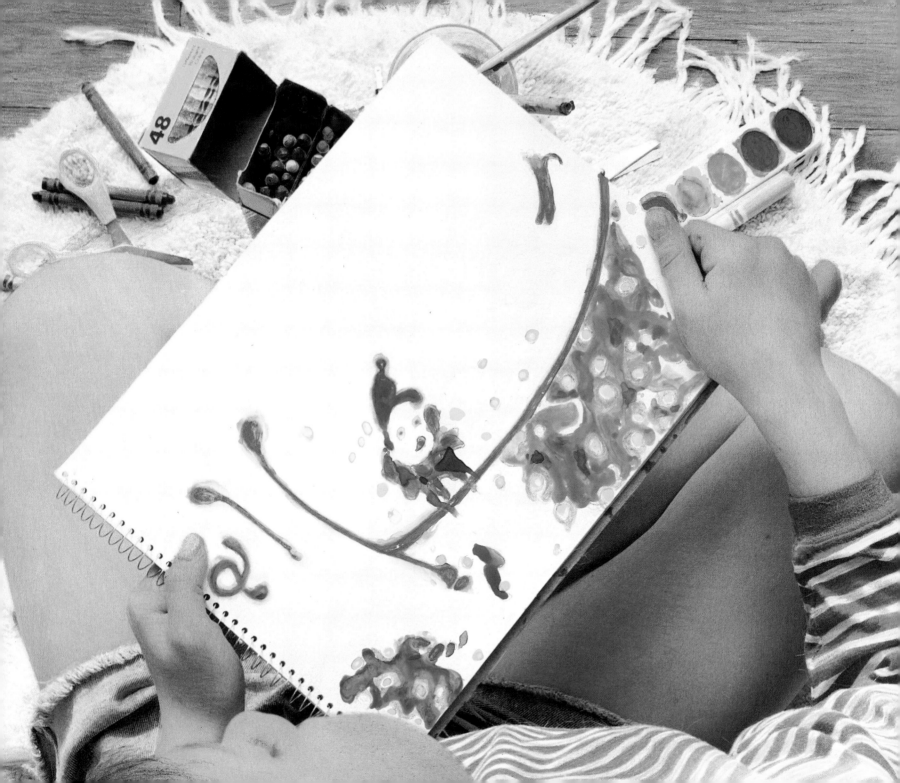

I studied the paper and looked upside down.

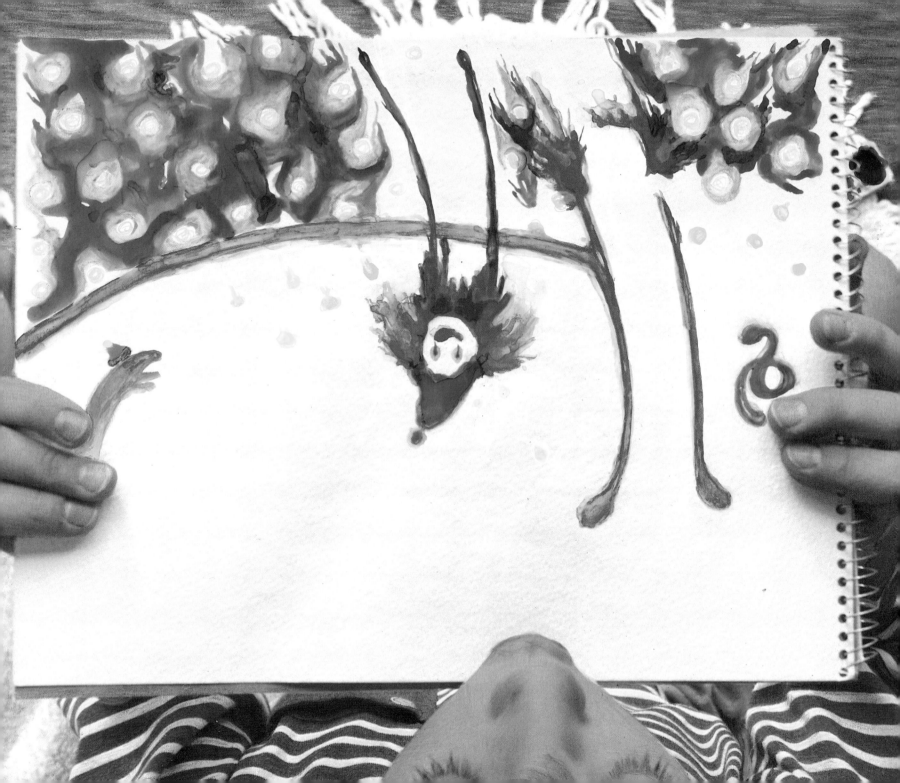

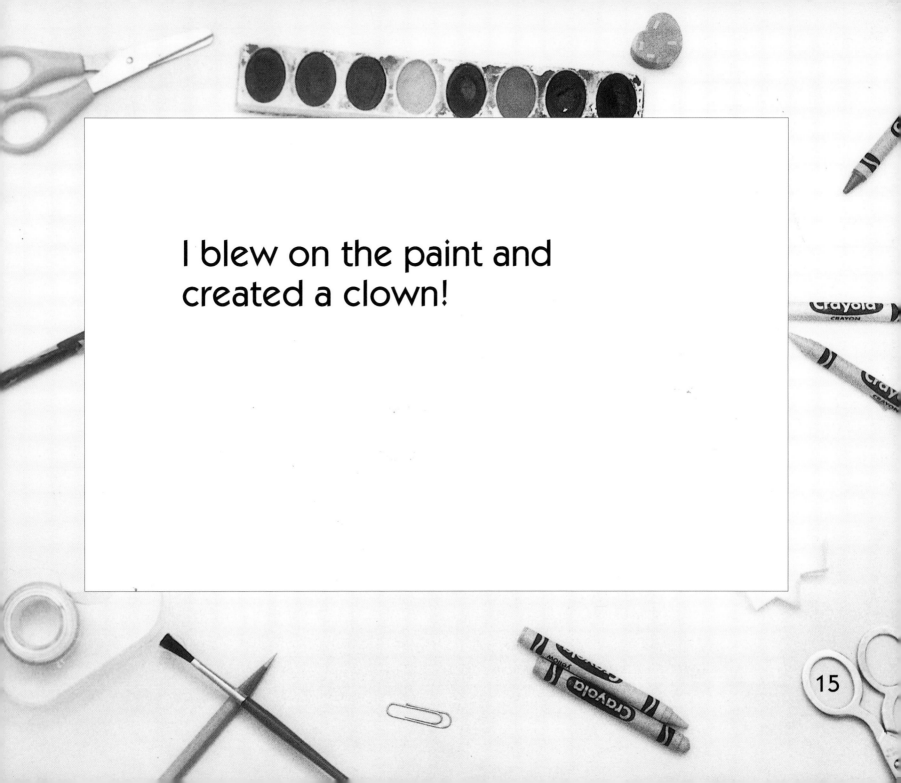

I blew on the paint and created a clown!

15

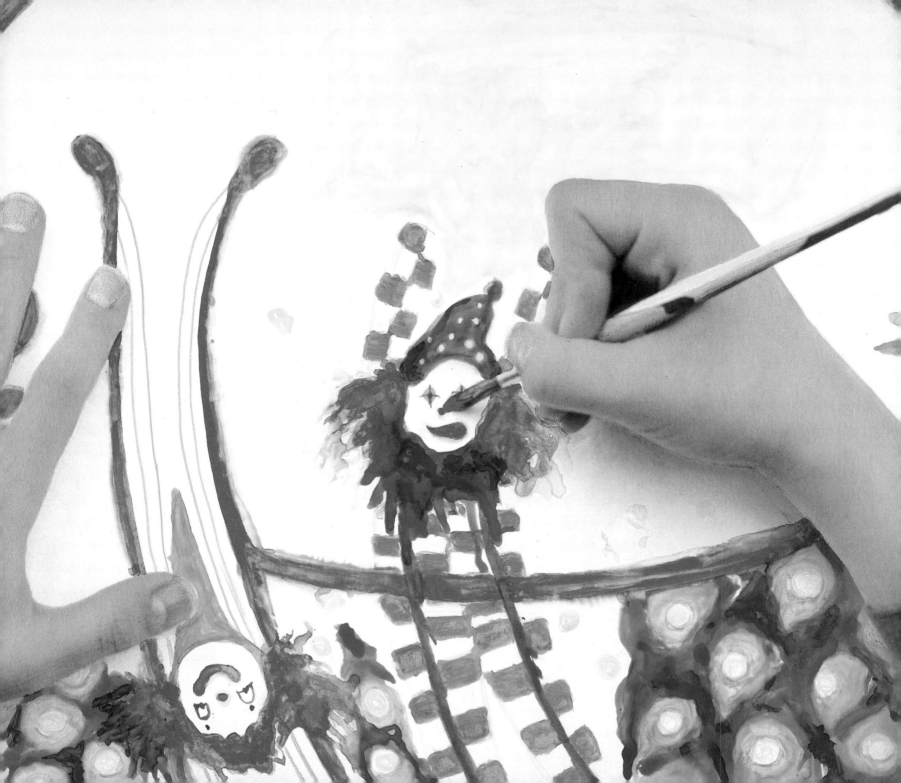

I painted some heads, some arms, and then legs . . .

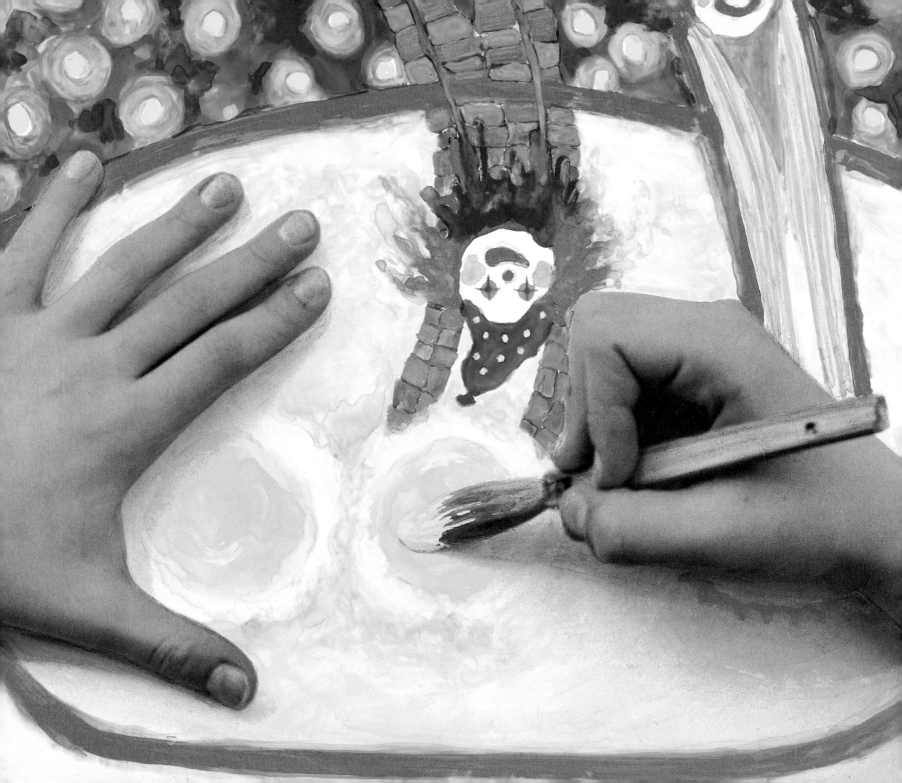

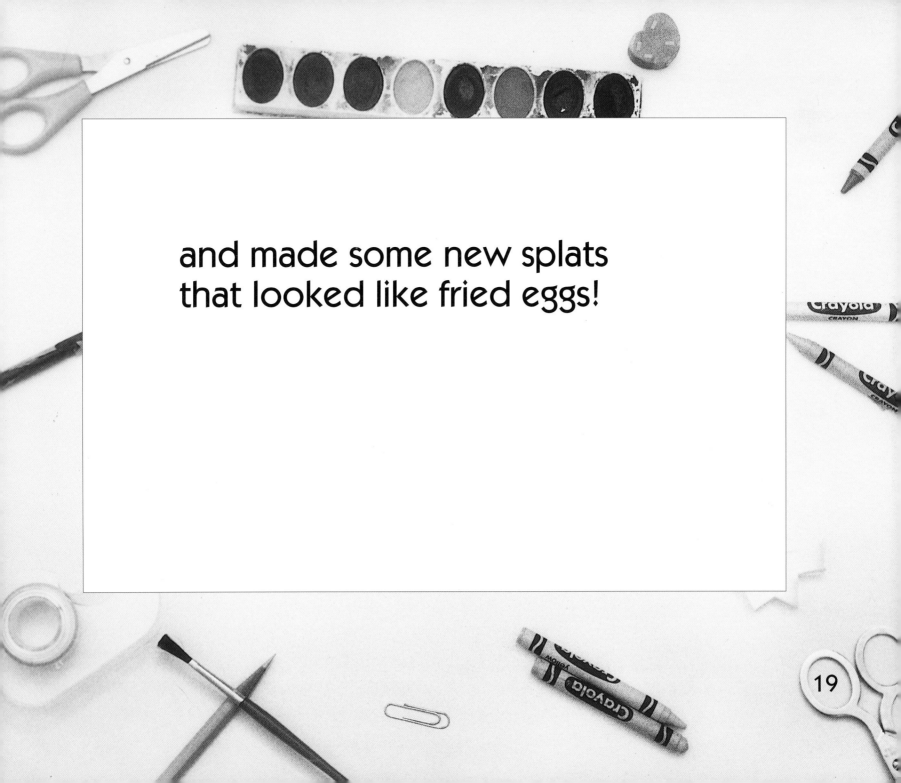

and made some new splats
that looked like fried eggs!

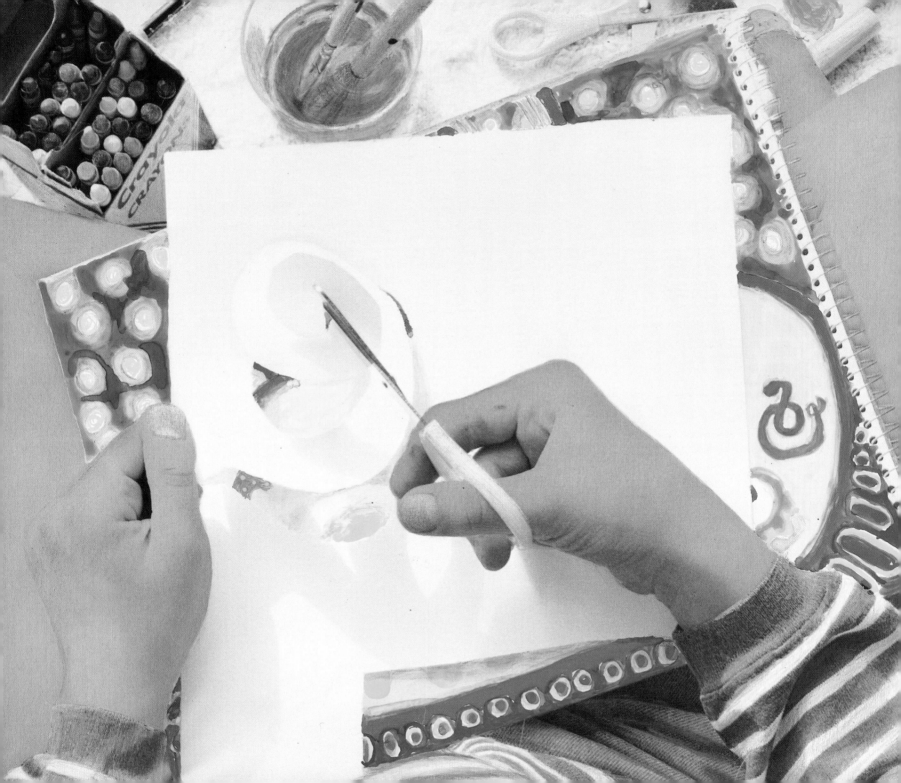

What fun! What a blast!
I would make this fun last!

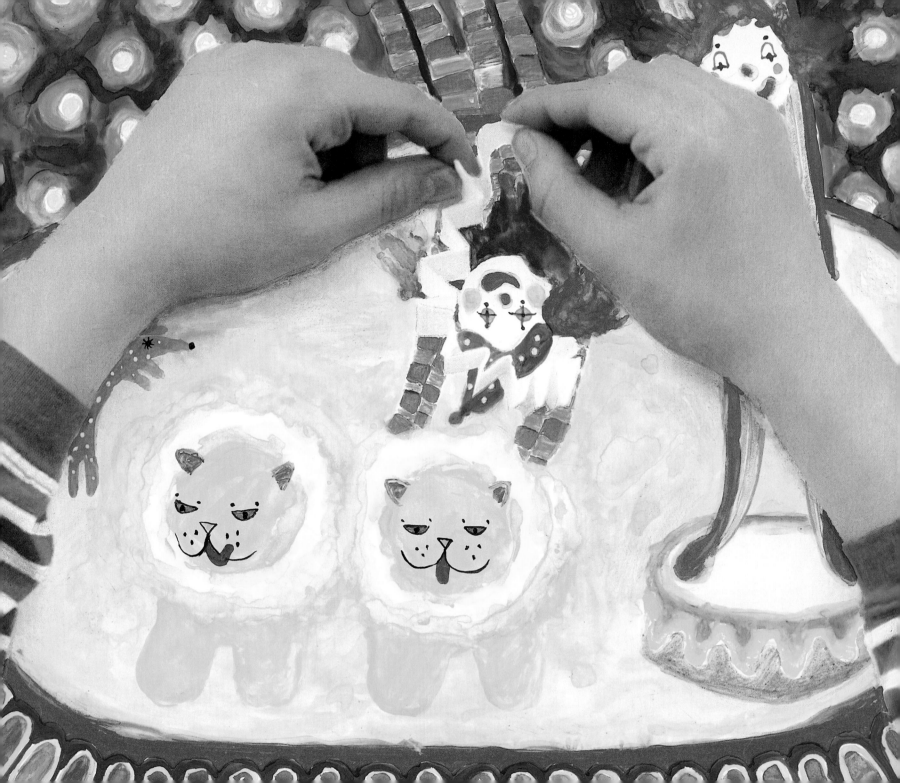

Creatures from circuses burst
into sight . . .

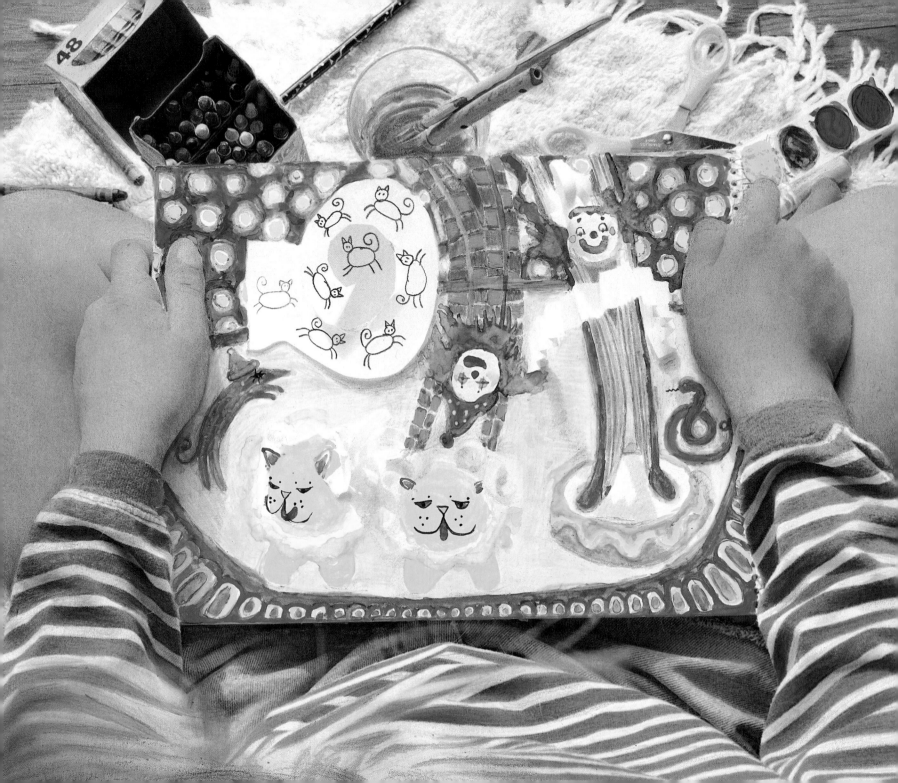

from dreams and from nighttime, from bright morning light.

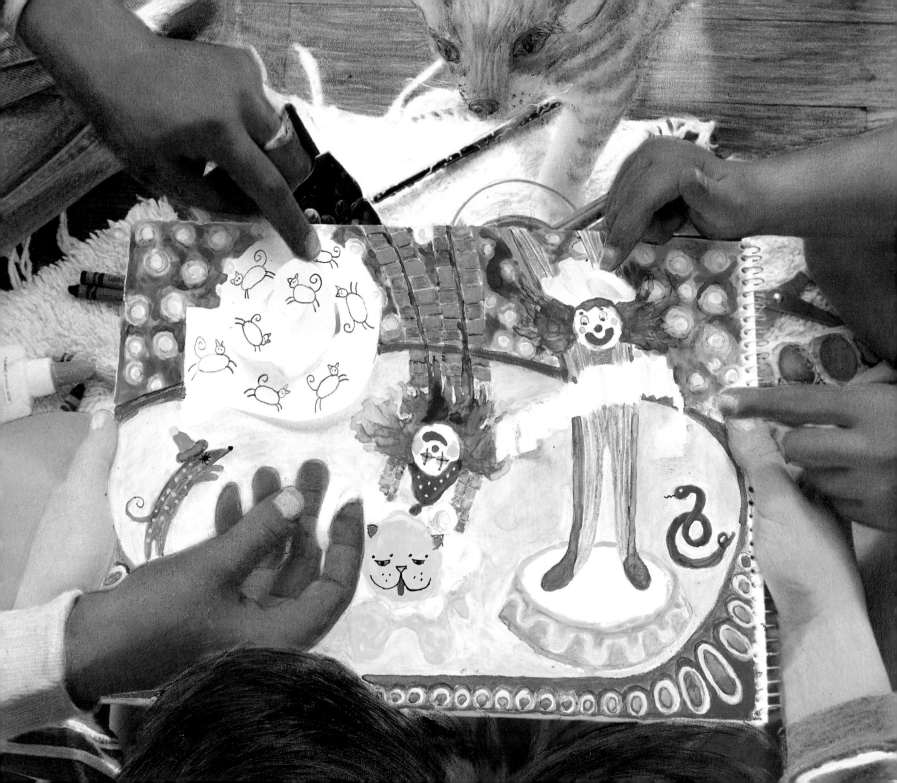

When my friends saw this art,
they asked what it takes.

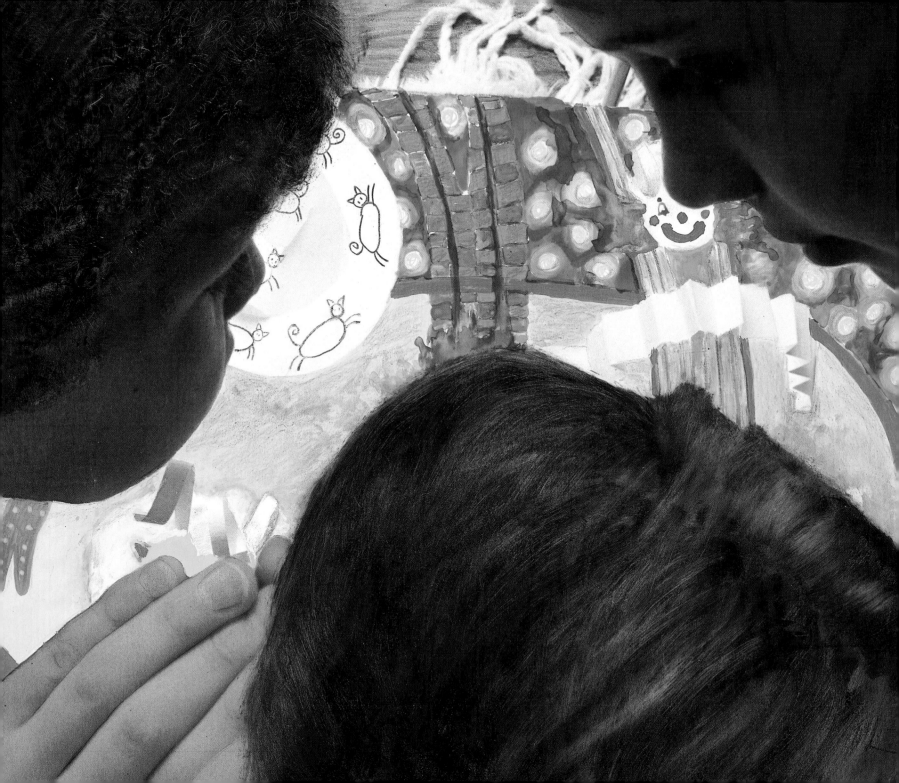

So I told them my secret . . .

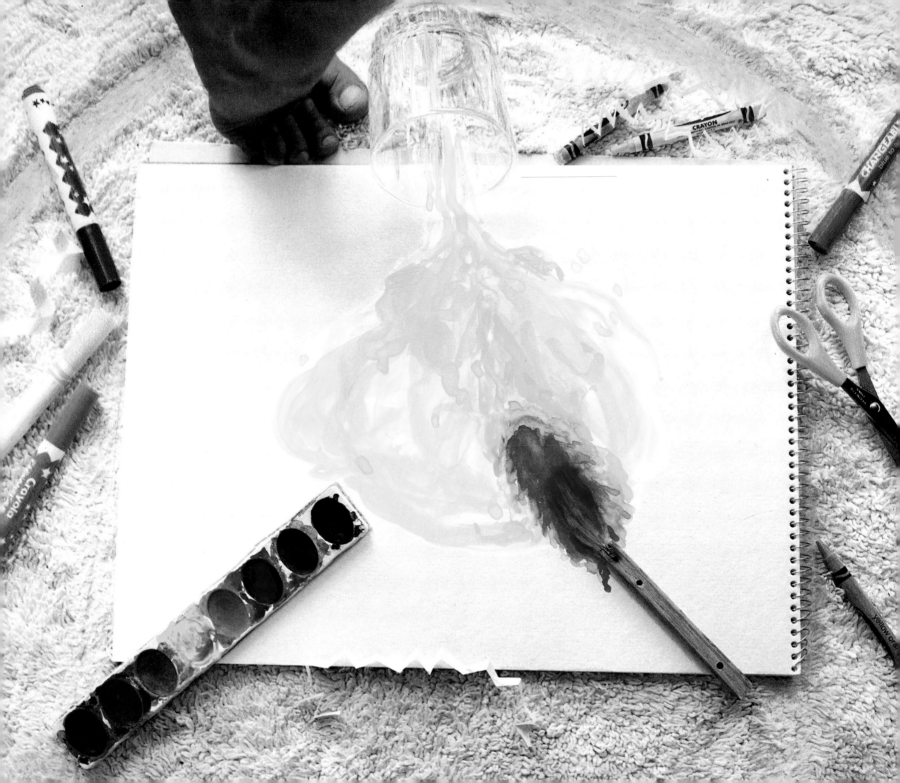

just make some mistakes!

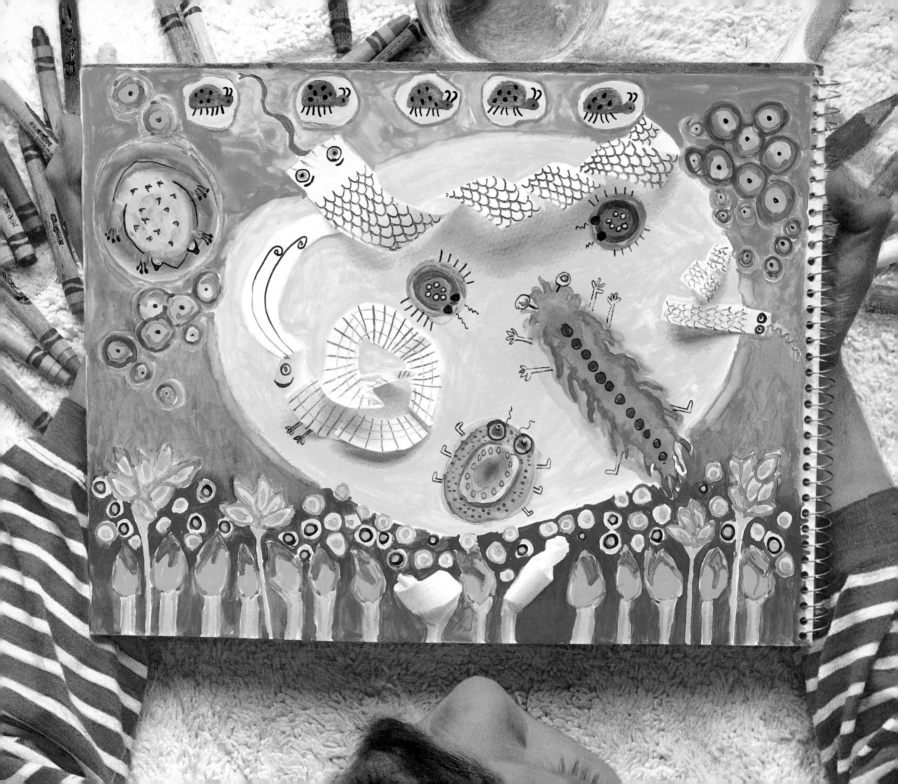